NETWORKING
WITH A PURPOSE

NETWORKING WITH A PURPOSE

HOW I BUILT MY POWER TEAM, RAISED 16
MILLION DOLLARS & GOT ON HGTV!

Amy Mahjoory

Networking With A Purpose
How I Built My Power Team, Raised 16 Million Dollars & Got On HGTV!

Copyright:	© 2018 Amy Mahjoory
Website:	www.amymahjoory.com
Author:	Amy Mahjoory
Edition:	First Edition

National Library of Congress Cataloguing-in-Publication data:

Library of Congress Control Number: 2017919773
Amy Mahjoory, Chicago, IL

Disclaimer

This book is dedicated to my mom and dad. Thank you for holding yourselves and our family to such high standards and for always inspiring me to be the best version of myself.

ACKNOWLEDGEMENTS

Writing this book was one of the most challenging projects I have ever completed. What was supposed to take three months took two and a half years. Thank you to everyone who supported me throughout this process and helped me bring this work to life. I would like to extend my sincerest thanks and appreciation to:

- Mark & Anne Lackey who taught me so much about the book writing process. Thank you for your patience, thank you for helping me define my vision for this book and for ultimately finding my voice!
- Glenn A. Williams for being an understanding accountability partner, mentor and coach! Thank you for micromanaging me through each milestone and giving me that extra push as needed.
- Mama Mahjoory for always seeing the silver lining and instilling your optimistic can-do attitude in me and everyone you encounter. Your ongoing support does not go unnoticed.
- My dad for believing in me and supporting me. Especially through the tough times. Thank you for your ongoing support and words of encouragement.
- Shirin Mahjoory for always pretending that everything I share with you calls for a celebration, even when that's not always the case.

- Jorge Gera & Joe Prutch for being the best photographers a girl could ask for!
- Christian Weatherspoon for your hard work and patience. Even when I genuinely believe I can get through an intro video in just one take.
- Vera Alexander for your personal branding & web development. Thank you for your innovation and enthusiasm throughout this project!
- Bryan Stacy for leading me to my true passion, renovating homes and mentoring other, in an industry I knew nothing about.
- Randy Frase for believing in me and for having a genuine interest in my success.
- Laura Patterson for always having my best interest at heart.
- Rima Muribi for being my voice of reason and shoulder to cry on.
- For my inner circle who inspire me daily: Natalie Ormos, Allison Mills, Erin Mottola, LaDonna Smith and Rachel Cosby.
- Than Merrill, Paul Esajian, JD Esajian and Konrad Sopielnikow for your ongoing guidance and support. You have provided me with a life changing opportunity, for which I am forever grateful. Thank you for playing such an incremental role in my ongoing growth, development and success.
- To my husband Sean McNicholas. I can't imagine life without you. Thank you for your endless love and support.

I am so lucky to be surrounded by amazing friends, family, colleagues, mentors and coaches. Thank you to everyone who believed in me and for believing enough in this work to turn it into a book that will help motivate and inspire others.

THE AUTHOR

Amy Mahjoory is the founder and president of Blue Ink Homes, a multi-million-dollar real estate investing company based in Chicago, IL. Prior to creating Blue Ink Homes, Amy earned her Bachelor of Arts in Supply Chain Management from Michigan State University and her Master of Business Administration majoring in Operations Management from St. Edward's University. For fourteen years, Amy worked for Dell Inc. in Austin, Texas where she became a highly recognized global leader in Procurement, Logistics and Operations Management.

Amy's success can be attributed, in large part, to her team-building talents and cutting-edge business systems. She focuses on surrounding

herself with some of the most dynamic and dedicated entrepreneurs, mentors, peers, employees and investors. Her strengths include strategic networking, team building, problem solving, outsourcing and raising private money.

Amy has a genuine interest in helping others succeed. Most of Amy's success originates from her belief in working smarter, not harder. Amy is an expert real estate investor, entrepreneur, published author, TV personality, national real estate coach and motivational public speaker.

Amy's number one goal is to provide the absolute highest level of service to her clients.

TABLE OF CONTENTS

FOREWORD

BY THAN MERRILL, CEO OF FORTUNE
BUILDERS, INC.

As one of the co-founders of FortuneBuilders and CT Homes, I meet a lot of people who share my passion for real estate. I have bought and sold hundreds of properties, including everything from single family to multifamily to commercial properties, some of which have featured on A&E's hit TV show Flip This House that I co-host.

When I first met Amy Mahjoory she was grappling with the challenge of transforming her dream of becoming a Residential Redeveloper into a reality. She was contemplating trading the security of a career in management with a blue-chip firm for the freedom of being self-employed in her own real estate business.

Amy quickly understood that there is a distinct difference between a real estate investor and a real estate entrepreneur. She had already made the shift from tactical thinking (working "in" a business) to strategic thinking (working "on" a business) during her successful career with Dell. She achieved this by being an uber networker and outsourcer, freeing her up to design and improve the systems that underpin the success of her business unit.

I encouraged Amy to take some time out of her busy schedule to write the book you now hold in your hands. Unpacking the way you do what you do is not easy. However, I know from my own experiences

of co-authoring The E-Myth Real Estate Investor with Michael E. Gerber and Paul Esajian, that taking the time and effort to decode your expertise further deepens your mastery in that domain. Now, I am excited to share with you the result – a book that will guide you to find the critical intersection of your passion, purpose and strengths.

As Jeff Bezos observed "One of the huge mistakes people make is that they try to force an interest on themselves. You don't choose your passions; your passions choose you." Whether you share Amy and my passion for real estate or not, Amy's book Networking With A Purpose will encourage you to pursue passions that have already chosen you.

Her conversational style of writing is immediately accessible. Her practical tips and thoughtful suggestions will have you taking new actions in between turning pages. Her story and dynamism have the power to energize you - to interrupt the drift of life as usual and inspire you to transform your dreams into reality.

The enigma of Amy is that she is both intense and relaxed. Savor that contradiction as you let the tapestry of her stories and ideas wash over you like a finely woven Persian carpet upon which you sit together, sharing a cup of aromatic tea.

CHAPTER 1

RAISING ADULTS

It takes a village to raise a child

You may have heard of the African proverb that "it takes a village to raise a child". It takes many different people, with different attitudes, skills, strengths and styles to teach a child what they need to know to find their way in life. A child needs nurturing from their family, friends, and the local community in which they live, to flourish.

The basic meaning of this saying is that child upbringing is a communal effort. The responsibility for raising a child is shared with the larger family (sometimes called the extended family). Everyone in the family participates - especially the older children, aunts and uncles, grandparents, and even cousins. It is not unusual for African children to stay for long periods with their grandparents, aunts and uncles. Even the wider community gets involved such as neighbors and friends.

You raise a child by meeting their physical, emotional, mental and spiritual needs.

You raise an adult by meeting their physical, emotional, mental and spiritual needs.

However, the same person has a different set of needs during these two primary stages of their life.

It takes a network to raise an adult

I've also come to appreciate that it also takes a village to raise an adult. However, a different kind of village - one that provides a different kind of sustenance. The kind of nourishment that supports an adult in realizing their full potential comes from a network.

Do you want to be successful in your career, continuing to be promoted for new opportunities over the course of several decades? Or, do you want to be successful in establishing and cultivating your own business, so that it continues to flourish for years to come?

To raise a successful adult - who can lead an organization (either their own or someone else's) to new levels of prosperity - you need to be well networked. The village you need is not necessarily the one you were born into. Likewise, the village you need will change over time. In fact, for you to truly thrive, you are going to need to intentionally create the right kind of village around you. One that can nurture your development, with useful contacts, the right information, interesting opportunities and a myriad of other resources - in a way that allows you to also give more than you get. You see, when the exchange of value within your network is positive - your network continues to grow, both in size and quality.

I was fortunate to be born highly networked - I grew up with three mothers and three fathers. Networking is something that I have studied, practiced and learned a lot about over the course of my corporate career, through the process of launching and growing my own business and as a result of becoming a professional public speaker and presenter.

You need to create a village around you = your network

We live in a hyper-connected world. It is imperative that you (and your career or business as an extension of you) become hyper-networked.

In this book, I am going to help you:

1. Understand what's holding you back from connecting more meaningfully with others
2. Re-imagine the role of networking in your life and business
3. Teach you the five most important lessons I have learned about effective networking
4. Share with you my best tools and techniques for networking naturally

The objective of this book is to share the specific networking strategies that have helped me reach my personal and professional goals, so that you can leverage from this platform and system to achieve your goals while working towards becoming the best version of yourself. After reading this book, you will have the knowledge and education required to implement these proven systems and strategies into your own business, process or day to day lifestyle. It doesn't matter if networking is currently a weakness or towering strength, and it doesn't matter what your personal or professional experience entails. It is however important for you to be coachable and implement what you find valuable from what I teach.

Networking is one of the most effective and affordable strategies when it comes to marketing you or your business. Understanding how to identify your target market and knowing how to leverage from the resources around you will play a major role in delivering quality results through strategic networking.

"What's the secret to networking?" you may be asking.

I've discovered that networking is not something you do. Networking is actually a way of being. Networking is a habit, a behavior, that comes from a particular mindset.

People grow from connection - because connection is the wellspring of creativity. We can achieve much more when we work together than we can in isolation. Yet, some people find it easier to connect with (and stay connected to) other people. However, it does not have to be

that way. Connecting with others is something that human beings do naturally.

Now that I have shared with you a bit about what networking means to me, I imagine that you're curious to understand how I came to believe that networking is the key to your happiness, health and high performance in life.

So, let's start at the very beginning! I am going to share with you the story of my life so that you can see how important networking has been in helping me mold and structure my career. It played an integral role in helping me start my own company in an industry I knew nothing about, build my power team, raise millions of dollars and obtain a four-part series on HGTV while building lifelong friendships!

CHAPTER 2

BORN NETWORKED

I come from a strong family background with very high expectations and core values. Specifically, when it comes to continuous education and job security. According to my family, leaving my secure and stable corporate job; to launch my own career as an entrepreneur in an industry I knew nothing about, was less than ideal. However, I realized the importance of building a village of support, above and beyond my family and friends, whom I believed in, to help reach my new goals.

Don't get me wrong, my family is comprised of several successful entrepreneurs dating back to the early 1900's, so they weren't entirely opposed to the idea. My grandmother was one of the very few women in Iran who first worked in the fashion industry. She was hired by a large textile/design manufacturing company that manufactured fabric for custom clothing orders placed by overseas clients. The fabric designs were inspired and created by my grandmother.

My great aunt was also an entrepreneur as she owned and managed a private technical school that taught women how to create

patterns and design various articles of clothing from beginning to end. This was in an era when women were housewives and never held a professional job of their own. My mom and several of my aunts followed in their footsteps when they immigrated to America and Germany while attending graduate school. One of my aunt's went on to own her own custom clothing company for over twenty years which was tailored towards high profile clients. Another one of my aunt's currently owns and operates a restaurant and bar in Passau, Germany which has been in business for nearly thirty years. However, as much success that we've shared, came failure, and the fear of that ongoing failure weighed heavily on my family members. Especially, my dad.

My life has always revolved around education. My traditional belief in education stems from a long line of parents, aunts and uncles, cousins, grandparents and siblings encouraging me to not only study, but to learn. I was taught at a very young age that any person is able to achieve success, but only those willing to learn will achieve happiness. Since their arrival in America over fifty years ago, my parents have strived to have the best for themselves and for their children. My father holds a PhD in Education Administration and my mother holds a Master's Degree in Education Administration; both from Michigan State University (MSU). My brother earned his undergraduate degree from MSU and his Master of Business Administration (MBA) from the University of Massachusetts at Dartmouth. Of my five double cousins (I will explain shortly), two are engineers with MBA's, one is a doctor, one a lawyer and the other obtained her Master of Science (MS) degree in Nutrition. My aunts and uncles are great lovers of all things related to learning, as they proudly hang framed copies of their family's degrees on their living room wall. I am proud to be part of a family that holds education in such high regard.

However, education means more to me than merely attending classes and taking exams. It is a path that allows a person to make a

living, make a difference and also, to make mistakes - for how are we educated if we cannot learn from our mistakes? Education teaches discipline, instils self-worth, and commands respect from others, but knowledge makes people strong, confident and willing to accept challenges and responsibility.

I was born and raised in Okemos, Michigan which is a small town adjacent to East Lansing, Michigan where the majority of my thirteen family members and pursued our education at MSU. I come from a fairly unique family dynamic - my mom and her two sisters married my dad and his two brothers. No, none of it was arranged. Shortly thereafter, they all immigrated to Okemos, Michigan and purchased homes within three miles of one another.

That said, I only have one brother by birth but we look very similar to our five double cousins. My cousin, Zahra, and I looked almost identical growing up. We speak the same, sound the same and encompass that twin vibe where she finishes my sentences and knows exactly what I'm thinking based upon the look on my face. We all shared the same last name growing up and five out of the seven of us went to the same middle school and high school. Our dads played along anytime teachers or friends had a case of mistaken identity and my aunt Shirin would call into the main office to dismiss me from class whenever my mom was unavailable. Close friends of ours and former classmates still refer to all of us as siblings.

I usually compare my family to the family from the movie My Big Fat Greek Wedding (minus the Greek part!) as everyone in our family is so involved in one another's lives. Growing up with such a unique family dynamic definitely had its pros and cons. All three sets of parents HAD to be consulted regarding any major decision we wanted to make, which I clearly was not a fan of. Poor "outsiders" as every guy who married into the family had to obtain permission from all three sets of parents, lol....However, that was positively offset by the family traditions we created over the years. Especially, our Sunday dinners. To further display how close our families were growing up, I've attached an image

of a note my uncle Ramez wrote to me inside of a book (A Children's Atlas of all things) he gifted me on my tenth birthday

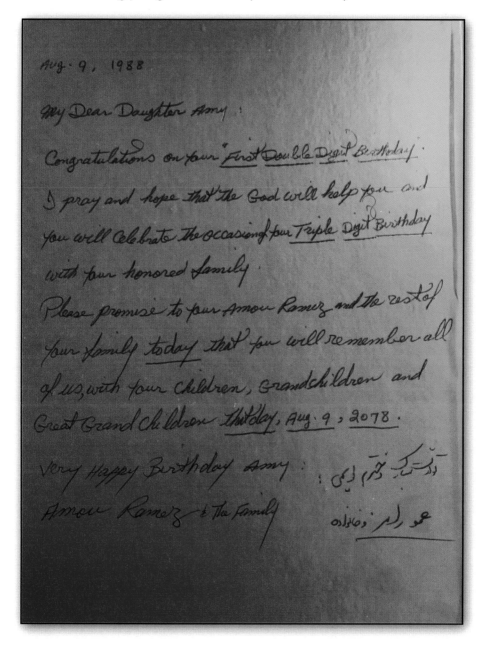

One of the most difficult and life changing events I've ever had to experience was watching my uncle Ramez loose his battle to cancer in October of 2013. It was the first time anyone in my immediate family passed away prematurely and it was the first time I witnessed how quickly the human body is capable of shutting down and deteriorating in just a matter of weeks. I'll never forget that evening in October when I walked into my aunt and uncle's house when my uncle was released from the hospital for home hospice care. I stood inside of the house at the entrance for a few minutes before I could force myself to walk into the family room where he was resting on the couch. My aunt Shirin and cousin Rima were seated in two small chairs right next to him making sure he was never left alone. I wasn't able to look him in the eyes or I'd cry. I focused on his forehead as I selfishly asked my aunt to cover up his shoulders so that I couldn't see how fragile he was. That night, with the help of my cousins Rima and Zahra, my uncle took his last lap around the kitchen, through the dining room and back into the family room. That was the last time we'd see my uncle walk. Several days later, he passed away at peace and at home with all of his family by his side.

My uncle's passing helped put things into perspective for me and I suddenly realized that it was time for me to figure out what I wanted to do with my life. My Why became time. Time is everything. It compelled me to take action and make some uncomfortable life changing decisions because I quickly learned that you never know what tomorrow will bring.

The rest of my story is relatively traditional. Just like most of you, I was working for someone else and I was ready to make a change. After graduating from MSU in December of 2000, I got my first "real"

job with Dell Inc. headquartered in Round Rock, Texas just outside of Austin. I was only twenty-one years old when I had my first taste of corporate America. It was the first time I had ever permanently moved away from home to a new city I knew nothing about, the first time I was forced to create a new circle of friends outside of the circle I grew up with, the first time I bought my own car and it's also where I eventually ended up buying my first house.

When I think back to how all of this came together during my senior year of college, I am still shocked with how I ended up receiving an offer from Dell. This also happened to be the ONE and ONLY job offer I received coming out of undergrad. I must have interviewed with at least ten other companies. I remember wrapping up my first-round interview with a former peer, Uttam Reddy, who proceeded to ask me if I had any questions about the role. Little did I know that was my queue to impress him with all of the research I had completed prior to our meeting. I had nothing. I thought about it for a second, smiled and kindly responded with, "No thank you." He responded with, "Aren't you even interested in learning about Austin?" It's embarrassing for me to admit this now, but I had ZERO idea that the job required me to move out of state.

Somehow, I ended up getting a second interview which was scheduled to take place onsite in Austin (thanks Uttam!). I took a more professional route this time and spent several days researching the company and the role. I knew that I wanted the job the minute I landed in Austin and met with the team. I don't remember the details of how the second interview ended but I do remember flying home the next day and checking my email as soon as I got home that night. I couldn't believe it. I had an offer waiting for me in less than twenty-four hours. I was clearly going to accept their offer but thanks to the ongoing mentorship of my brother, cousins and parents, I picked up the phone the next morning and called Dell's HR department in an effort to negotiate the terms of my offer. I believe the original

offer started out at $40,000/year but I was able to negotiate it up to $45,000/year. Who knew?! All I had to do was ask and they came up an extra $5,000. Not bad for a first time negotiator!

For the first fourteen years of my career I worked solely for Dell. I worked in all aspects of Supply Chain Management. Everything from managing the back end operation for all of our customer field returns to negotiating multi-million-dollar contracts and pricing with several of our high profile vendors on the production side of the business. This also happened to be my one and only job in the corporate world since graduating from college. I was blessed with an amazing opportunity to travel the globe without realizing all of the basic foundational business skills and tools I was picking up along the way. I established lifelong friendships and I am extremely grateful for the opportunities Dell provided. Although my strategic agility and ability to effectively deal with ambiguous situations helped me reach and exceed many of my corporate goals and objectives, I had come to a fork in the road and I was forced to make a decision. I wasn't passionate about what I was doing and as a result, I had zero desire to take that next step to further advance my career.

I became extremely complacent and comfortable. I was never a manager of people at Dell and for fourteen years I worked as an individual contributor. However, towards the end of my career, I realized that strategic networking enabled me to outsource and automate nearly eighty percent of my daily responsibilities. Suddenly, the concept of working smarter as opposed to working harder was starting to settle in. I clearly encompassed a powerful skillset but I wasn't exactly sure where or how I was going to use it. I knew it was time for a change but the element of fear kept holding me back. Shortly thereafter, I came to the realization that networking is truly a daily habit. It's not something you do, it's something you build. This belief has since then been the foundation of my day to day operation in and outside of the workplace.

The time had finally come where I had lost all motivation and desire to complete even the simplest tasks. I would be asked to take on certain responsibilities or to deliver projects within a certain timeframe but there was nothing I could to motivate myself to either 1) commit to getting the job done or 2) push it onto someone else through my outsourcing process. I had to make a decision. Either recommit to Dell or respectfully part ways. I had spent so much time there, just shy of fourteen years, that I didn't want to end my career with any negativity. I absolutely dragged it out longer than I should have but I eventually submitted my letter of resignation which went into effect on May 29, 2015 and then sent my entire organization the following email:

> **From:** Mahjoory, Amy
> **Sent:** Friday, May 29, 2015 11:17 AM
> **To:** CSS Americas Service Logistics; DCS Services Extended Team
> **Cc:** Guerra, Roman; Villamizar, Audrette
> **Subject:** Thank You & Farewell!
>
> **Dell** - Internal Use - Confidential
>
> Team,
> Hope this message finds you well! Over the last 14 years, I have had the pleasure of working with an amazing group of cross functional individuals and have established lifelong friendships which I am forever grateful. I was only 21 years old when I started my first "real job" in corporate America and I could not have been more proud to work for such a globally recognized and well respected corporation like Dell. While I am excited to pursue my passion as a full time residential redeveloper, I will greatly miss all of you whom I have worked with over the last 14 years. That said, my last day at Dell will be today. Thank you again to everyone who has played such a major role in my growth and development and cheers to a prosperous FY16!
>
> Below is my contact info for those of you who would like to stay in touch.
>
>
> Amy Mahjoory
> Blue Ink Homes, LLC
> www.blueinkhomes.com

FINALLY! I was able to set the element of fear aside and take that next step in pursuing my dream of becoming a fulltime Residential Redeveloper.

Now What?!

I don't pride myself on being creative. I actually consider it a major weakness of mine but I've always had a passion for renovating homes. I was that girl sitting at home watching HGTV but I NEVER encompassed

an entrepreneurial mindset. I've always been fascinated with the idea of taking an old dumpy house, and bringing it back to life by turning it into something new and modern. I remember sitting at home talking to my best friend's husband who worked as a Relationship Manager in the construction industry and I danced around the idea of partnering with him on a project. However, since I knew nothing about building homes, I wasn't sure how to move forward with next steps and I didn't want to spend time figuring it all out on my own or learning via trial and error – the stakes were too high.

When in doubt, I always turn to education, coaching and mentorship. However, education to me is not constrained to formal studies at school or a university. I am a subscriber to the idea that education means life-long learning. I searched my mind for useful concepts that I had been exposed to through reading business books as an adult and talking with other successful entrepreneurs around me. The idea that continued to rise to the top was the belief that every new business owner wears three hats:

1. The Entrepreneur (this is your inner dreamer)
2. The Manager (this is your practical side), and
3. The Technician (this is you as a worker)

Assuming these three different personalities was one of the core concepts I had taken away from bestselling author, Michael Gerber's book entitled *The E-Myth Revisited: Why Most Small Businesses Don't Work and What To Do About It.*

I had come to understand that successful people think about WHO needs to be on their team before they bother

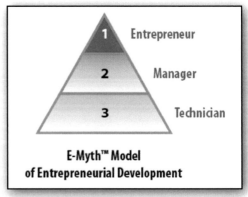

E-Myth™ Model
of Entrepreneurial Development

contemplating HOW to achieve their goals. So this is what I planned to focus on first!

When Preparation Meets Opportunity

I am a firm believer in Seneca's quote, a Roman philosopher, who stated, "Luck is what happens when preparation meets opportunity". I wanted to ensure I had the right education in real estate as my foundation, before pursuing my entrepreneurial vision in real estate as a full-time career.

There is more to success than pure luck and everyone's perception of luck if different. If you read Richard Wiseman's ten-year study on how you control your own luck, you will begin to see that "Luck isn't just about being at the right place at the right time, but also about being open to and ready for new opportunities." You can read more about this study via http://lifehacker.com/5472904/create-your-own-luck-by-changing-your-perspective and http://richardwiseman.com/resources/The_Luck_Factor.pdf

This is where the power of education and practice comes into play! Through education comes confidence and with confidence comes passion and energy. The more educated you are, the more successful you will be at influencing others to share your vision and assist you with next steps. They'll be excited to be a part of something new while working towards a mission they also believe in.

That said, I decided to make an investment in my real estate education by hiring some of the industry's best real estate educators at FortuneBuilders (learn more at http://www.masterycoachingwithamy.com) to coach and mentor me along the way. That's when my business, Blue Ink Homes (www.blueinkhomes.com), was born.

FortuneBuilders can be compared to the ivy league of real estate investment companies. This company, which includes its leadership team from the top down, prides itself on teaching this business the right way. Especially when it comes to sustaining exceptionally high

values and standards. They take a lot of pride in leading, inspiring and educating others without compromising their ethics, morals or values. It is because of the systems, tools, coaching, guidance and ongoing support that FortuneBuilders provides, that I was able to hit the ground running, build my power team and purchase and renovate ten properties during my first full year, while still working a full time job.

From Humble Beginnings

I grew up as an extremely shy individual, even around my family. I vaguely remember running home from kindergarten one afternoon because I was SOOOO excited to tell my mom how proud I was of myself. That afternoon, instead of standing in front of my teacher waiting for her to notice me, I decided to take action and pull on her skirt. I also remember the time I went over to my aunt's house and wanted ice cream, but for whatever reason I couldn't articulate that to her. Instead, I grabbed onto her leg and dragging her towards the freezer.

I NEVER thought that I'd end up on stage teaching and mentoring hundreds of aspiring real estate investors across the nation or land a series of television shows with a major network like HGTV speaking in front of a national audience. However, when you are genuinely passionate about something it doesn't feel like work and it is something you'll want to share with the entire world. Hopefully, in a humbling and respectful way.

Unfortunately, I have lost some of my closest friends throughout this process. While they may say that we naturally parted ways, a part of me wonders if it's because I pushed them away by spending so much time and energy trying to convince them to start their own business. My encouragement to them came from a good place. I saw all of the possibilities that starting your own business could lead to and I cared so much about my inner circle that I wanted the best for them. However, I finally came to realize and accept what may be right for me isn't always right for someone else. It took me over a year to realize that I can't force change onto someone who 1) doesn't want to it, 2) isn't ready for it or 3) doesn't believe in it. My passion in living a lifestyle by design is what inspired me to take a vested interest in coaching and mentoring others. Specifically, those who have a genuine interest in learning.

I am extremely proud of the *blood*, sweat and tears my team and I have put into creating Blue Ink Homes. We take a lot of pride in going above and beyond to improve every neighborhood that we work in by revitalizing it - one home at a time. All the functional appliances, cabinets and countertops we remove during the demo phase are donated to charities tied to those in need. We have established new relationships with local non-profit organizations that benefit from the use of our old reclaimed wood, doors and fireplace mantels.

Working with HGTV and the team at Pie Town Productions is an opportunity that I am extremely and forever grateful for. The ability to work with such a talented group of cross functional professionals has been a very humbling and surreal experience. It has allowed me to leverage from a national platform and build new relationships, friendships, benchmark best practices, understand lessons learned and showcase our beautiful homes while highlighting the success of our team.

Not everyone in your network is created equal but I do believe that everyone plays an important role. Consider that you are the

average of the five people you spend the most time with and it is your responsibility to surround yourself with the right people.

What Makes Me A Networking Guru?!

I've been investing in real estate for the last five years and I've completed over forty million dollars in transactions. The result is that I was able to walk away from my corporate job and live a lifestyle by design. I have created and stabilized a multi-million-dollar real estate business with no previous real estate experience. I now spend half the year in San Diego while my team manages the day-to-day operation in Chicago. This does not necessarily mean that I take six-months off. Instead, I have the flexibility to be away from the job site because of the eighteen months I put into building my power team. After countless interviews, relationships and failed attempts (or lessons learned) at getting the right people on the bus, I now have a team of subject matter experts I depend on and trust when it comes to managing the day to day operation of Blue Ink Homes. This allows me to spend my time focused on the strategic and revenue generating activities. If you are a business owner or if you choose to eventually start your own business, then a large chunk of your success will depend on the team you build. Be very selective with who YOU choose to bring onto your team. We have multiple renovations being managed simultaneously while other pillars of my business are being developed. My husband and I have already taken three international vacations and we're only half way through the year. I have the flexibility to spend even more time with family and friends while giving back to others as needed. I have been blessed with an amazing opportunity to work with HGTV on a four-part series of House Hunters and House Hunters Where Are They Now and I am able to dedicate more time towards paying it forward by improving every neighborhood we work in. I am a national real estate coach, mentor and motivational public speaker. I don't share this with you to brag about my accomplishments. I share this with you

to highlight how much you can accomplish, if you choose to do so, through strategic networking.

You may be asking yourself, "Sounds great but what's in it for me?!" I am going to introduce you to the same networking systems and strategies I implemented to build my power team, raise over sixteen million dollars and get on HGTV! As a result, your confidence in implementing these proven networking systems and strategies will grow and you will have the education and knowledge needed to pursue your own dreams. You may also be asking yourself, "If you're doing so well, then why are you sharing your secrets to success with me?" I truly believe that the more I give, the more I grow. I also believe that experience and knowledge is meant to be shared and the best way to learn something to further grow and develop is to teach it. I ask myself every day, "What can I do today that will make a difference?" A difference in the lives of my family and friends, my colleagues and team members, the neighborhoods we work in, and most importantly, the hundreds of students I continue to coach and mentor across the nation. I have always looked for ways to improve my quality of life and by doing so, I strive to improve the lives of those around me, whether in the classroom or the boardroom.

Over the course of the next five chapters, I am going to share with you the five most important lessons I have learned about effective networking:

1. Eat, Pray, Love & Network – *networking is a daily habit*
2. Know Who Is In Your Village – *networking is personalized marketing*
3. Build A Village Of Support – *networking begins with giving*
4. The Power Of Why – *networking unlocks opportunities money can't buy*
5. The Village Square Is Actually A Circle – *networking is intentional*

I am going to share with you the stories and experiences that helped me learn these lessons. Furthermore, I am going to introduce you to my best tools and techniques for networking naturally to fast track your training and development in how to build the kind of village around you, as an adult, that will ensure you flourish. My intention is that as we work our way through these lessons together and you apply the ideas I teach you, at some point you'll realize and remember that you were born networked too.

CHAPTER 3

EAT, PRAY, LOVE... & NETWORK

Lesson #1: Networking is a daily habit

What is strategic networking?

Strategic networking requires a mindset shift. It's a task you're going to implement into your DAY TO DAY lifestyle. It's not something you're going to focus on weekly or monthly. It takes time for networking to deliver the results you are trying to achieve. Success will not happen overnight which is why it's important to be consistent with the systems you set up.

You're ready to take action. Now what?! Who do I network with?! Where do I go?! What do I say?! Those are all phenomenal question and the answer is everywhere with everyone! The concepts I am about to introduce can be applied in any industry from starting, stopping or growing a new business to building new personal and/or professional relationships.

When I told you to network with everyone, I wasn't joking! I live in a high rise building staffed with a fulltime onsite doorman. I am constantly stocking the front desk with my business cards and flyers for James to pass out as he deems fit. This wasn't a system I implemented overnight. It takes time to cultivate relationships and it's important to know your audience and understand the approach that works with

one person may not work with the other. Building rapport is HUGE! I'm always offering to grab the management office, door staff and engineering department coffee and snacks as I come and go. Especially during special occasions like a birthday or holiday. My building has over five hundred units in it and the majority of folks who live in the building are tenants which means there is a TON of opportunity for me, as a residential redeveloper, to target landlord investors interested in selling their units now or in the future. That said, strategically networking with people who work and live in the building has provided me with another network to leverage from. This same concept can be implemented in neighborhoods with a homeowner's association. Talk to your neighbors, educate them on who you are and what you do (it doesn't have to pertain to real estate). This is a great way for you to market yourself while developing new relationships. Depending on your approach, building trust and rapport with everyone you encounter will generally reflect positively on you and your business. Come from humble beginnings and stay true to yourself.

Living in the city doesn't require me to drive often so I'll usually walk, take the train or sometimes I'll hop in a cab or call an Uber. I purposely ask my Uber drivers what they do outside of Uber, which naturally triggers them to ask me what I do for a living, which then provides me with an opportunity to rattle off my sixty second elevator pitch about what I do as a residential redeveloper. It's a great way to strategically transition the conversation and casually start to market you and/or your business. It's also a great way to practice and get comfortable being uncomfortable☺

I even network at the grocery store. Think about it, the employees interact with the neighbors on a DAILY basis!

Always have a stack of business cards readily available to handout as needed. Consider taking it a step further by carrying marketing flyers in your bag or car so you can post them on the bulletin boards at the local grocery stores, gym, coffee shops and restaurants.

Anytime I need to deposit a check or withdraw cash from my account, I take the time to plan ahead and set aside fifteen minutes for me to bypass the ATM, walk into the local branch and say hello to my account manager who then assists me with my transactions. Why is this important? Facetime! I am focused on building rapport. Now that I've cultivating a long term relationship with my banker, anytime I see him in or outside of the office, I'll kindly remind him to keep me in mind as a referral if he comes across anyone in his inner or outer circle who has expressed an interest in diversifying their portfolio and investing in real estate. I apply the same concepts at local restaurants, sports venues, fundraising events, the theater, various Dr.'s offices, with my attorneys, title companies, financial advisors, etc. Talk to anyone and everyone! Be strategic even when going out with friends and family but also take the time to be present when you're with them in a social setting.

What are you willing to "sacrifice" or temporarily part with in order to achieve your dreams? How can you strategically replace activity A with activity B without feeling like you're giving up something that's important to you? It's not REALLY a sacrifice if what you're willing to give up will help you achieve your goals. Always remember to have an opinion and remember what your goals and objectives are. If someone asks you where to go, then maybe you consider suggesting a location or activity that MAY also provide you with an opportunity to strategically network. For example, when friends ask me if I have an opinion on where I'd like to go for lunch or dinner, in the past I'd always suggest something convenient and close to home. Now, I'll think about what the bottlenecks are in my business and potentially recommend places where I may have an opportunity to strategically network, assuming the

timing is appropriate, with someone who may be able to help address those bottlenecks.

Where Do I Go?!

We've talked about who you should talk to but how can you proactively get in front of your audience? One of the concepts that has worked well for me when it came to building my team and raising private money was networking in AND outside of the real estate industry. Log into www.meetup.com and conduct a key term search on entrepreneurs, venture capitalist, startup businesses, new business ideas, inventions, etc. Plan to attend as many events as you can and take it a step further by scheduling these events as recurring meetings into your weekly marketing plan. It doesn't matter if it's an event with a group of entrepreneurs in the tech industry, the food and beverage industry, the gaming industry, pharmaceutical sales, etc. as every entrepreneur has had to build a team and/or raise private money. That said, if they can't help you, chances are they'll know someone who can.

What other networking opportunities can you leverage from if you live in a small town or if there simply aren't any networking events available in your area? Start your own! This is a fantastic way for you to springboard your credibility and become a subject matter expert in your local market. If you're not sure how to fill the time, approximately two hours, then start by inviting guest speakers who are local experts in your industry or other guest speakers who have a product or service to market, assuming the material and content is relevant. Most service providers/guest speakers will be open to the opportunity because it provides them with another platform to market themselves, their business and their products or service while increasing your credibility. Just make sure these speakers come highly recommended from trusted sources and that you've completed your own due diligence ☺

I have met so many professionals throughout my career who have expressed concerns with time management. There's not enough time, they don't have anymore time to give, they already work in a high demand tightly controlled environment so more time isn't an option, they have a family and children to care for, etc. All of these feelings are very common and normal. As entrepreneurs and business owners, it's important for us to think big picture. This is where the concept of strategic outsourcing comes into play as you continue to build your power team:

Step 1 - Start by creating a priority list of the activities that consume most of your time. These tasks usually end up being the most tactical/administrative ones such as bookkeeping, responding to voicemails and emails, organizing your files, etc. Don't think about who you're going to hire or what you're going to do next. Don't even worry about the investment needed to hire someone to help. Eliminate all hypothetical what if scenarios from your mind and first focus on creating your list.

Step 2 - Start by hiring one virtual assistant (VA) who will take on one task at a time beginning from the top of your priority list. Not sure how to hire a VA? Talk to your mentors, talk to others who have hired a VA or Google it. Remember to LEVERAGE from the resources around you.

Step 3 - Once your VA has consistently delivered high results (a minimum of one full quarter) then, increase their workload based upon the remaining items on your priority list.

Step 4 - Once your primary VA has taken on as much as he/she can, then hire a second VA and guide them through the same vetting process for whatever tasks are still on your priority list. One of my VA's who started out as my blogger ended up being my part time project manager over the course of eight months and she lived in the Philippines!

There are so many routes you can take when it comes to hiring a VA. You can hire a third party VA staffing company which is my preferred method. Or, you can go directly to the VA via various global freelance websites such as www.upwork.com or www.fiverr.com but you'll want to ensure you've come up with very clear and concise training documents, understand how to properly vet them, and take the time to train them.

There is so much a VA can do for you! I am a huge believer in integrating networking into your day to day lifestyle. However, I still take the time to carve out one day a week to fine tune my networking systems and really hone in on strategic networking. For example, when I first started my company, one of my VA's, Anna, had access to my calendar and every Thursday she would pre-schedule eight, thirty minute 1:1's, for me to meet with individuals she had already pre-screened. Anna was a licensed agent in Sacramento and understood the real estate industry in general so she had the confidence to blindly reach out to individuals in and outside of the real estate industry. It didn't matter that she lived in Sacramento and I lived in Chicago. She understood the market. Anna focused on reaching out to individuals with common interests who could potentially add value to our business model and vice versa. The objective of this first step was for Anna to confirm that there was value in the face to face meeting. Anna was excellent when it came to dealing with ambiguity and problem solving so she would proactively search for these individuals online through various social media sites. The main platform we used to implement this networking strategy was www.LinkedIn.com Below is a summary of how the process works:

Step 1 - Conduct a key term search on LinkedIn for the types of individuals you are interested in networking with. In my case, it was private lenders, investors, wholesalers, cash buyers, realtors, etc. However, don't limit yourself to ONLY networking with professionals

in your industry. For example, other key terms for private money lenders outside of my industry include stockbroker, investment banker, financial advisor, etc. These individuals don't necessarily work in the real estate industry but they may know of someone with excess funds interested in diversifying their portfolios and investing in real estate with a high rate of return. This is the approach I take when reaching out to these individuals via steps two and three below. I make it clear that I'm not trying to "steal" their clients rather I'm looking to build a long term funnel of referrals for the both of us.

Step 2 - Message them via LinkedIn (one paragraph max) letting them know that it looks like you work in a similar circle/industry and there may be opportunities for you to work together/share resources so you're reaching out to see if they have time for a ten-minute exploratory discussion over the phone. Fifty percent of these individuals will not respond and you're not going to follow up with them. The purpose of getting the other fifty percent, those who do respond, on the phone is for you to vet them. Are they really who they say they are? Do you like the way they sound? Is this someone you'd like to associate yourself with? Etc.

Step 3 - If they pass your preliminary screening process above, then step three is a thirty-minute face to face meeting where you'll educate them on your goals and objectives. In my case, it was my private lending process or cutting edge team building process. I also provide each individual I meet with the applicable credibility packet(s) for them to take home and keep. Always end every conversation by thanking them for their time and expressing your excitement about developing a long term relationship.

Step 4 - Follow up one week later with a phone call asking them if they have any questions on the credibility packet/informational packet you left them with.

Results will not occur over night. It took me eighteen months of CONSISTENTLY implementing this process before my power team was in place. Networking is intentional. It unlocks opportunities money can't buy. The best way for you to network with a purpose is to turn networking into a daily habit and remember to always keep the end in mind.

Hiring a VA is a great investment. It allows you to leverage off of other people's time so you can focus on the things you're good at and enjoy. Google "100 things a VA can do for you" if you need additional ideas on what tasks you can begin to outsource today! Several additional examples of how a VA can help you include:

1) Complete online research to help you identify best practices and implement lessons learned with whatever it is you are try-ing to accomplish.
2) Improve your organic ratings and rankings on Google through Search Engine Optimization (SEO).
3) Write your blogs.
4) Manage your social media accounts.
5) Build your core website.
6) Answer and return phone calls.
7) Organize your virtual files.
8) Respond to and manage your emails.

Over time, you can also outsource certain tasks to some of your cross functional team members. For example, after I established a solid relationship with one of my Realtors and after I was able to increase my credibility with him through repeat business, I trained him on the process I use to analyze each of my deals. This empowered him and his team to take the initiative to analyze each of my deals before sending them to me for review. What's in it for them? Why would they take on this extra work? Having someone, or a team of individuals, familiar with how I analyze deals improves my response time because

it makes my decision-making process much easier and faster! A faster response time resulted in more deals for both of our teams.

My General Contractor (GC) also project manages (PM) his own projects, my architect expedites the permit process and my designer works directly with my GC and my Realtors on design ideas to ensure everything is aligned with what buyers want while still maintaining our budget. Yes, we still make mistakes and no, nothing is ever perfect.

I've discovered that networking is not something you do. It's something you build. Networking is a way of being. It's a habit and a behavior that comes from a particular mindset. Integrate networking into your day to day lifestyle and you will do great things!

I made the decision not to mention my corporate job with Dell when I first launched Blue Ink Homes because I didn't want to take any attention away from my newly formed company. I didn't have any previous real estate experience but I didn't allow that to hold me back. If you find yourself in a similar situation, then don't talk about the past rather focus on the future and take the initiative to share your vision and goals with your audience. In the beginning of my real estate career, I wore a black Nike bracelet which served as my constant reminder to network daily. The same concept still applies when I find myself working as a Technician in my business. The black bracelet serves as my personal reminder to outsource the tactical administrative tasks so that I can focus on the big picture and overall strategic objectives of my company.

Networking is not something you do, it's something you build

Networking versus your network. There is a difference! Networking is a process of its own and it is something you'll implement on a daily basis. This process will require you to make a strategic mindset shift. It will help you to build your power team, also known as your inner circle, which can also be referred to as your network. You're going to encounter all sorts of individuals through various means of strategic networking so always remember to keep the end in mind as you figure out how these individuals align within your inner and outer circles.

Networking in the way I see it is a critical component of my success - a natural, daily habit and constant activity. You never know when or where you may meet someone you connect with and who may also be able to help so you always want to be ready and prepared to perform - to talk clearly and confidently about who you are and what you do. Always have business cards, brochures, informational packets, etc. on hand.

Your network is an asset, each time you add new people and/ or nurture relationships with existing members of your network, you increase the value and power of your network. Your network can also be something you have built such as a business, an event or your database. Your network is not just a list of names and contact details. It is a web of experiences and impressions which in turn is a reflection of you and your business.

The benefits are endless! Over eighty percent of my success originates from strategic networking. One of the most important reasons to network is to build your power team. Remember, you are presenting others with an opportunity to work with you. Be very selective with who you choose to bring onto your team. I often find myself quoting Jim Collins, from his best-selling book, Good To Great:

"You want to get the right people on the bus and the wrong people off the bus. Then, you want to put the people in the right seats on the bus and then the bus will take you where you want to go".

It is because of my power team that I can manage my business remotely. I have a team of A+ players working together because it delivers a higher quality product and service and provides me with a high level of confidence which in turn gives me peace of mind. It provides me with the flexibility to focus on the things I want to focus on personally and professionally.

Very seldom will I hire employees through public job posts although that is how I first started. Most candidates now originate from referrals. I'll usually start by reaching out to friends, business partners and other professionals in the industry. This is how I was introduced to my main acquisitions manager who helped my business double its revenue when I first broke into the industry. It has also resulted in several amazing lifelong friendships.

It takes 60 seconds to make a friend

A lot of people never grasp the concept of me being a business owner in a male dominated industry. Here is a perfect example of the conversations that takes place whenever I tell someone (male or female) what I do for a living...

Them: So what do you do for a living?

Me: I'm a residential redeveloper and we renovate around 8-10 homes a year.

Them: So you're a builder?

Me: Not exactly. I buy, renovate and then sell distressed properties.

Them: Oh, so you're a Realtor!

Me: No, I "flip" houses.

Them: So you have your GC license?

Me: No, I don't need a license to do what I do. I simply buy, renovate and then sell distressed properties with a team of experts who support me.

Them: Wow, that's a lot of manual labor. Aren't you exhausted?

Me: No. I'm not the one BUILDING the house. I have a team of experts such as licensed GC's, designers and architects who I've hired to take care of RENOVATING each property and then I work with my realtor who will sell the home once the renovation is complete. I work with multiple realtors, contractors, designers and architects who help bring the vision together.

Ten minutes later and we're all on the same page regarding what I do. However, ninety percent of the time, their follow up question is, "How can you afford to buy all of those homes at once?" This is where the concept of targeted networking comes into play. This is also one of the questions I've been building my audience up to. That's when I immediately shift gears and rattle off my 60 second elevator pitch created for prospective investors.

A powerful pitch will have an exponential effect on your first impression! Spend time crafting your elevator pitch. This should be a short and sweet summary of who you are, what you do and why people love working with you! The goal is not to exceed 60 seconds because you don't want to lose your audience and there is no reason why you should need more than a minute to educate people at a high level on who you are and what you do.

Remember, great networking is like a three course meal! Your 60 second elevator pitch is not your first answer to the common question, "So, what do you do?" Think of your 60 second elevator pitch as the main course, before which you are going to serve your guests an

entree, which opens their palette, stimulates their senses and triggers their curiosity. It primes them for what is to follow, so that your 60 second elevator pitch (or main course) is appropriately received by a guest hungry to know more. It is the art of serving a well-controlled portion, that is presented attractively, and that leaves room for dessert. When your guest then subsequently asks you for your business card or follow up meeting, it's because you've served them well.

So, now it's time to plan your menu, for those important guests at your table. You'll need to visit www.networkingwithamy.com and download the 60 second elevator pitch template I have prepared for you to develop your own.

The password to download all networking tools is networkingwithamy.

CHAPTER 4

KNOW WHO IS IN YOUR VILLAGE

Lesson #2: Networking is personalized marketing

Even though I wasn't working as a full time residential redeveloper until May of 2015, I spent whatever free time I had working in my business whenever I could find the time. The majority of what I did in my real estate business in 2014 was network. I spent most of my time meeting with new folks in and outside of the real estate industry. I quickly learned that it was ok to get creative when it came to networking and that I didn't need to limit myself to only networking with other real estate professionals.

My main goal was to network with other entrepreneurs in addition to real estate professionals. However, I wasn't concerned with the industry these other entrepreneurs worked in. My justification behind it was 1) all entrepreneurs have had to build and/or lead a team and 2) the majority of entrepreneurs have been tasked with the challenge of raising money. That said, more than likely, if these individuals couldn't help me out directly, then I was optimistic that they'd be able to point me in the right direction and refer me to someone who could! I was simply looking for people who encompassed a clear set of leadership skills, in addition to subject matter experts, in the areas of my business that still needed some work. My main objective was to build my power team. My strategy during my first year was to start small and focus on

condos in the city because the risk and investment was minimal and I was still educating myself on the Chicago market while systematizing certain parts of my business. This strategy also allowed me to fine tune and tweak my power team as needed. I still can't believe how I stumbled across my GC.

I took the advice of one of my all-time favorite mentors, thank you JD Esajian, and posted an ad for a labor quote only for a full bath renovation, via www.homeadvisor.com. I had already met with five GC's when a sixth one called and expressed an interest in walking the

subject property. This was the first condo I was in the process of renovating in downtown Chicago. The name of this GC's company was misleading as it had absolutely nothing to do with construction/ renovations, so my assumption (never assume!) was that he was simply coming over to quote one portion of the job. After walking around the unit for several minutes, this GC asked me if I was interested in having him bid the entire job. This was a great lesson learned for me because I never would have traveled down that path simply as a result of the name of his company. However, his question triggered me to follow up with several additional questions which ended up with me awarding him the entire job. His pricing was average. He wasn't the most cost effective but he wasn't the most expensive. However, I've come to learn that it's not just pricing that plays a role in this decision making process. His competitive pricing, combined with his project completion time, response time and proactive communication during the course of the Request For Quote (RFQ) were by far the best! Although I felt

cautiously optimistic about his ability to deliver a high-quality product in a timely manner, I still continued to micromanage every step of the renovation. Five years later and this GC is now my full time dedicated contractor who has also grown into a great personal friend.

That said, anytime I come across other real estate professionals who may not initially seem like a good fit, I always follow up with a series of questions incase there is a better fit for them in other parts of

my business. Or, incase I am able to help them out by referring them to someone else.

Unfortunately, we live in an increasingly impersonal world. However, by understanding (and practicing) that networking is personalized, 1-1 or 1-group marketing, you'll stand out in all the right ways.

Invest 60 minutes to make a friend in 60 seconds

Always know WHO is in front of you BEFORE they are in front of you. In other words, do your homework. Due diligence is so important when it comes to meeting with someone for the first time. Especially if they are a decision maker. I like to believe that it takes 60 seconds to make a friend if you invest 60 minutes researching them before you meet with them. It is equally as important for you to gather your thoughts and spend some time preparing for each of your meetings. Always create an agenda and publish it prior to your meeting. Arrive with a color copy of your portfolio or presentation which you will leave with them so that you have something to follow up on. Create your list of questions in advance. Be clear and concise with your goals and objectives so your audience understands 1) who you are and what you do, 2) what's in it for them, 3) what's in it for you, and 4) what's the call to action or next step.

Once you have a good idea of who you will be meeting with, it is important to understand how you plan to kick off the preliminary meeting. ALWAYS be on time and recognize their time is just as valuable as yours. Remember, you have already set the expectation on how much of their time you would appreciate so ensure you are as efficient as possible in delivering valuable content. Why should they be excited to work with you? How can you help them? Understand how to ask the right questions that are genuine and professional and then pull information from those responses to guide the conversation. Don't ask them 600 random questions because you're nervous or

because you didn't prepare for the meeting. What value do you bring to the table? What's in it for them? Remember, networking should be mutually beneficial. Don't be a one upper, show stealer or strive to be the center of attention. Allow others to talk and learn to navigate through a mutual networking space. Ask them what they are/are not looking for. Come to the table with ideas. Use the power of networking to open doors. If they can't help you, then ask if they know someone who can as referrals and word of mouth goes a VERY long way.

Whether it's over the phone or in person, remember to listen! It is important to ask the RIGHT questions and to be present. NO CELL PHONES. Non-verbal communication is just as important as verbal communication. Dress appropriately, have a firm handshake, make eye contact, pull your hair back, uncross your arms, sit up straight and always remember to smile. If these concepts don't come naturally for you, then a great way for you to practice at home is to keep a mirror on your desks. This will serve as a constant reminder to always smile while you're on the phone. Why is this important? Your smile WILL naturally shine through on the other side of the phone. DO NOT take a call if you are lying on the couch, slumped over, or just woke up. You will sound uninterested and tired and that's not going to be a positive reflection of who you are or what you're doing. Why is this important? How many times have you been on the phone with someone who had zero energy or voice inflection? Remaining upbeat and energetic will help encourage you to smile and the person on the other line WILL notice it and appreciate it. There are a lot of times when I find myself pacing around my condo in circles while on the phone to keep my energy levels high. Remember to give first and expect nothing in return. Be respectful, personable and approachable. Highlight the fact that you operate well as a team player (unless you don't) as well as an individual contributor. People don't care about how good you are at whatever it is that you're doing. If they don't like you or trust you, then they'll be less inclined to work with you.

At the end of your meeting, remember to thank them for their time and express your gratitude. Also, remind them to reach out to you as a trusted resource and make it clear that you'll make yourself available in order to help them out as well. Implement a follow up system so that they take you seriously and don't forget about you. Several examples of ways you can to stay in front of your audience include a follow up call, email and/or monthly/quarterly newsletters. Make sure your newsletter and social media accounts all link back to your core website.

Make Business Personal

Once you've identified your decision makers, you're going to want to ensure you've established an authentic and credible online presence. This is very important before meeting with your list of influencers as one of the first thing someone is going to do before meeting with you is Google you Building a credible online presence with VALUABLE content will take time. It's not going to happen overnight so it's better to start this process sooner than later.

Since I didn't have any experience in real estate, one of my immediate short term goals was to focus on building a credible online presence. This was a three step process but I was able to find one mentor who was a subject matter expert (SME) in web design and search engine optimization (SEO) to help me through this process. The team at MindProtein (http://mpbyamy.com) was able to create my core website for Blue Ink Homes (www.blueinkhomes.com) in addition to assist with the majority of the content required in just a few days. Their ongoing

support and guidance has been invaluable in understanding the steps I needed to take in order to 1) build a modern day core website with complexities built into the site including key terms which help my site rate and rank higher on Google, 2) they also took the lead on helping me create multiple squeeze pages (www.rehabbingchicago. com and www.remoterehabber.com) and 3) they helped build out my social media sites. The support they continue to provide, especially as technology and SEO continues to grow and evolve, allows me to step away from the tactical administrative parts of my business so that I can focus on the more strategic revenue generating activities.

Integrating blog articles into your core website is also important. Fortunately, the team at MindProtein also helped me to strategically define what this would look like. You can outsource this to a VA or you can write a handful of 300-word blog articles yourself. However, unless you love to blog, then writing your own articles may not be the highest and best use of your time. If you choose to outsource this task, then you'll want to ensure your VA understands your vision. You'll also want to provide them with an outline of what each article will entail. Then, prior to publishing each article to your core website, you will review them. Uploading blogs to your core website is another strategy to help build your online presence. It is also important to integrate key terms into your each of your blog articles which your VA can also assist with strategy will assist in improving your rating and ranking on Google. However, there is a process involved behind identifying the appropriate key terms to use so ensure you understand the process in detail so you can be selective with the VA you outsource this task to. Or, you can partner with the same third party who helped me with my key terms via http://mpbyamy.com

Once my core website, www.blueinkhomes.com was live, I focused on identifying additional elements to make the site more personal. For example, instead of using generic and random photos of houses or groups of people talking which you can download from Google,

I customized portions of my website with my own photos taken at various networking events, closings, property/site visits, etc. The same concept applied to short videos I'd take when walking a property before, during or after it was renovated, introducing Blue Ink Homes, my team, members of my family, etc. to my followers. I implemented this same concept into my blogs. Your audience wants to know YOU! Create an informative and fun website and take pride in highlighting your team, milestones, ongoing projects, how you give back to your community, etc. This is what will set you apart from others and help leave an impressionable mark.

One of the reasons I started my own company was because I wanted to create my own set of standards and move away from the traditional politics and red tape typically associated with working for someone else. Your audience will be more appreciative and it's going to help them to have a better understanding of who you are which in turn will get them to know, like and trust you. They WANT to get to know the real you! I remember when I hired a local videographer to help me record a before video for one of my first projects (click on https://youtu.be/wH-RX55yydg for the before video the videographer recorded & then click on https://youtu.be/edYYtccZk8Y for the after video which I recorded). I'm uncomfortable sharing these videos with you as my style has changed over the last several years and it was one of my first few videos but it's a part of how I've grown and developed. My idea was to submit the three-minute before video (which I later realized was WAY too long) to several different production companies in hopes of landing my own TV show (which I now realize is so much work!) but I quickly realized that the recording style the videographer I was working with used was unique to a show he had been working on for years and it just so happened that his style of shooting wasn't appealing to certain production companies. Overtime, I learned that everyone has their own style so trying to fit into someone else's mold wasn't the right approach for me. Therefore, as I continue to coach

and mentor others, I always highlight the importance of getting to know your audience and understanding what their requirements are and what their process entails before investing a bunch of time and energy into a project that may not accurately reflect who you are or what you do.

Another strategy you can implement in order to further develop your online presence is through social media. Establish accounts on the top four social media platforms which include LinkedIn, Instagram, Facebook and Twitter then hire a VA to help manage your weekly posts. Your VA can also assist in organically growing all your social media sites through their various posts, hashtags, likes, comments, etc. but ensure your VA understands how to effectively tag photos on all your social media accounts as this will capture the attention of other like-minded individuals. Checkout www.hootsuite.com when you have a few minutes as a tool you can leverage from in order to streamline your social media strategy. This site will allow you to preschedule each of your posts and then it will blast the scheduled post to each of your social media sites simultaneously! Create a weekly social media schedule so that you're strategically delivering valuable content to your audience. CONSISTENTLY providing your audience with valuable content will organically grow each of your social media sites. Perhaps it makes the most sense for you to set up all your usernames under your personal name. Or, maybe you prefer your usernames reflect the name of your product, service, company, etc. All my social media sites are set up under Amy Mahjoory, not Blue Ink Homes. I chose to market myself as opposed to my company because I felt like it was a more personable approach. All business owners are in a sales role. As your network starts to believe and trust in you, then overtime they will begin to believe and trust in your company.

Create your own YouTube channel and let your personality shine through! This doesn't have to be anything formal and recording short videos with your mobile device is fine. Don't stress about hiring a

professional or about creating the perfect video. I never thought twice about posting blooper videos on some of my social media sites because it displayed my vulnerable side and more importantly, its relatable. We're all going to make mistakes but embrace those mistakes and allow those imperfections and your personality to shine through. This is what will set you apart from others.

An excellent way to share information, documents, photos, videos, etc. with your VA, which they can use to help build your online presence, is through Dropbox or Google Drive. For example, I am constantly taking pictures of my GC and his team at various job sites. On occasion, I'll ask someone nearby/onsite to take pictures of me and my design team as we walk through multiple projects and evaluate them together. I implement the same process when attending networking events or if I'm hosting an event. During Christmas, we hosted a team lunch with over twenty of our sub-contractors which we captured on film and shared on social media and the team loved it. They felt appreciated, they felt like they were making a difference, and they felt like they were a part of a team. Be consistent with who you portray yourself to be online. Don't be one person on camera and then someone else completely different off camera.

There is a difference between strategic networking and socializing. You're not scheduling meetings and networking with others in order to socialize and chit chat about random day to day activities. Be selective with who you choose to meet with while also being respectful of their time.

Just do it! Take action now and be confident in who you are and what you're doing. Most of your confidence will originate from ongoing education combined with strategic networking. Surrounding yourself with likeminded people on the same mission as you is HUGE. Every time I leave the house I remind myself that everyone I encounter may be one phone call away from helping me reach my goal.

How can strategic networking help my business grow? That's a phenomenal question! Now that I have my power team on board, I have trust in a select group of individuals who act as my eyes and ears when I'm not always around. This plays a major role in helping me grow the business while staying on track with our long term strategy. Through effective networking, my team has learned how build rapport with numerous cross functional individuals who add a lot of value to our bottom line and vice versa. I have ongoing meetings and calls with my lenders, contractors, designers, realtors and other developers in and outside of my target market to discuss all of the different ways that we can work together to streamline our operations and help each of our businesses grow.

Be selective with who YOU choose to put onto your team. Who is going to add the most amount of value? Think long term and ensure they have a passion for what they are doing. Always operate with a growth mindset and create systems and standards for you and your business. This will help you identify the value added versus non-value added tasks and this is what's going to separate you from others.

The Strategic Networking Questions Cheat Sheet

The following exercise is comprised on 10 strategic questions you can ask at any general networking event to understand who you are talking to, what their objective is and how you can help them with their next steps.

1. What brings you here today?
2. Are you here alone?
3. What's your background?
4. Where are you from?
5. Do you have any previous experience with [insert topic of the event]?

6. What would make this a successful event for you?
7. If you can leave this event with one key takeaway, what would it be?
8. What are your immediate goals?
9. Which area of your business would you most like to improve?
10. How can I help?

You can memorize the list of questions above and practice them at home, in the office or with family and friends so that the questions eventually start to flow naturally in person. Also, remember to use the non-verbal body language pointers which you can download below. It is just as important to network non-verbally as it is to network verbally!

You can visit www.networkingwithamy.com and download a template for doing "The Strategic Networking Questions Cheat Sheet" exercise I have prepared for you.

When is it the right time to start networking? NOW! There is a very inspiring video of Art Williams speaking about the importance of taking action now which I'd like to share with you on YouTube via https://youtu.be/7R9c0RAz678 The message here is simple. Strike while the iron is hot and keep the momentum going. You're never going to be fully prepared for anything. Just do it!

CHAPTER 5

BUILD A VILLAGE OF SUPPORT

Lesson #3: Networking begins with giving

Another way to think about your network is to use an analogy to a vegetable garden. The soil, garden beds, nutrients, plants, etc. are all parts of your network – collectively, they create a system that will regularly bear fruit and create value - both for you and other members of your community.

Networking is like weeding the garden, watering the plants, adding fertilizer and flowers to attract bees. The difference between your high yielding garden bed and your neighbors low yielding garden bed depends on the underlying quality of your network and the care and maintenance you provide it.

In every village, there are people who knit their community together. They are privy to important information via the grapevine, they see and make key connections between people, they foster a sense of goodwill and generosity, that builds positive support. In this sense, networking is an important form of exercising leadership.

"A person's village of support represents a groundswell of people with whom you're not just acquainted with but who know you well (or at least feel like they do), and who like, trust, and respect you." Trevor Young

You need to cultivate the kind of relationships with people that lead to deep connections. You need to genuinely contribute value to their lives, relentlessly, over time – without the expectation of getting anything in return.

Adopting A Givers Gain Approach

This is a philosophy based upon the law of reciprocity (http://ivanmisner.com/givers-gain-is-a-standard-not-a-sword/) This is a standard expectation you'll want to incorporate into your personal and professional belief system. Educate others on how you can provide value to them and how you can help them grow. Give first and expect nothing in return. The law of reciprocity, "when someone does something nice for you, your hard-wired human nature determines that you do something nice for them in return," will naturally find its place back to you. Use the power of one connection to open doors. Continue to do this and you'll grow a positive reputation as someone who pays it forward.

Value other people's time

Keep it real - it's time to get personal! This is your time to shine and educate your audience on what sets you apart from others. Never mislead anyone and always be true to yourself. Everyone's time is valuable, not just your own. This is an important concept to grasp, especially when you ask people to take time away from their friends, family, work, vacation, etc. to meet with you. Get to know your audience. Do they come from a large family? What REALLY interests them? How can you help? What motivates and excites them? This is where the concept of know, like and trust comes into play. Once you have established these three concepts with your audience, then they are much more inclined to work with you. It is important to educate your audience on who you are and what you do. How do they begin

to KNOW you? Through your 60 second elevator pitch we discussed earlier. Then, overtime, not just after one meeting or phone call, they will decide if they LIKE you. For example, I don't care how successful you are or how much knowledge you may be able to share, if I don't like you, then I'm not going to work with you. I prefer to keep the culture within my inner and outer circle congruent throughout. That said, people who don't share the same mindset or belief system won't work well as a part of our team. Once your target audience knows and likes you, then they will eventually start to build a level of TRUST with you. This process takes time and will not happen overnight. However, once you have established this foundation, then they will be more inclined to move forward with next steps.

Your net worth determines your network

You may have heard it said that, "Your network is your net worth". However, I think that you need to flip that statement to understand and appreciate that your net worth determines your network. By your net worth, I mean your sense of self-worth.

If you don't understand your purpose and your values, then you can't build the right network around you. You need to understand why you do what you do.

Understanding Your "Why"

Before you get started, it is important to understand your Why. What is your purpose and goal for wanting to start a business, build a power team and take your skillset to the next level? How does your Why tie back to your goal? Is it something you want to benefit from personally, professionally or both? Are you doing something to gain exposure? If so, for what purpose? Perhaps your Why is to leave a legacy for your children, help someone in need or to achieve a lifestyle by design. Or, your Why may be better defined around a personal goal and

challenge. Something you choose to focus on as a part of your personal growth and development. Is your Why tied to something you want to do just for fun? Or for the simple pleasure of bragging rights? There is no right or wrong answer. Your Why is what will drive and motivate you when you begin to encounter challenges and fear so ensure that its clearly defined before moving forward with next steps. Define it and ensure that it acts as your driving force daily. Your Why should generate a burning desire and acts as the driving force behind what you are trying to achieve. Especially during the tough times. It's how you work through the tough times that will define you.

Even though my procrastinating habits have not changed ALL that much, I have identified it as a weakness. As a result, I made a strategic decision to outsource the tasks I don't enjoy. This concept had a snowball effect on my growth mindset and I quickly realized the power of leveraging other people's time. For example, when I decided to transition into real estate, all I wanted to focus on were the things I enjoyed. For me, that meant networking and developing new relationships. However, there is a lot more that goes into building a team and environment others enjoy being a part of. As a result, I worked with multiple mentors to create systems and tasks for the work that needed to be completed and then I on-boarded multiple VA's and a full time Operations Manager. As a result, I was quickly able to work ON my business instead of working IN my business and the investment in hiring multiple VA's and one full time Operations Manager was minimal compared to our projected growth. You may be asking yourself, sounds great but how does this tie back into my Why? Well, if my Why is time, and time is everything, and my goal was to live a lifestyle by design, then I needed to take action as soon as possible by expanding my team and outsourcing certain tasks and responsibilities.

I was passionate about my Why which helped keep the momentum going. It helped hold me accountable. Ok fine, a small part of me also

looked forward to proving the sceptics wrong but my Why is what triggered me to take action.

Having written goals is HUGE! It's a great way to help hold yourself accountable. One of my very first mentors (thank you David Giese!) always reminded me about the importance of writing down your goals. He taught me about the value of written goals and how written goals serve as a constant reminder to work through your daily tasks. Consider writing down your goals on a piece of paper or an index card and place it in your line of sight. Perhaps on the kitchen counter, refrigerator, dresser or bathroom mirror. Seeing your written goals throughout the day will encourage you to work through your daily tasks so you can cross them off the list and check mark them as complete. This will inspire you to continue to take action.

What are you doing to pay it forward and give back? What are you doing to inspire and motivate others? One of the reasons I decided to sit down and write this book is because I woke up one day and realized that so many of my students continued to ask me about networking. How to network, who to talk to, where to find these people, etc. Even though networking eventually grew into a natural strength for me, it took me YEARS to realize that not everyone is comfortable networking nor do they know how to get started. So I decided to write this book in order to share the networking strategies that worked for me.

What's in it for you? Why should you implement these networking strategies? People will naturally be drawn to you when you have something of value to offer them. Encompassing a variety of diverse skill sets will allow you have an even greater impact on who you attract into your network. It's also a great way for you to continuously grow and develop in certain areas. This all ties back to your Why. The ultimate result for me was being able to live a lifestyle by design. Strategic networking will allow you to focus on the income generating activities while continuing to build your power team. It will allow you to be more strategic with your time and work ON your business instead

of working IN your business. Strategic networking will help you reach your goal(s) while driving your company, team, product, service, etc. towards growth and stability. When you can rely on a power team to run the day to day operation, it will provide you with greater flexibility to live a healthy work-life balance so you can spend more time with family and friends, traveling and doing things things you want to do. You now have the OPTION to work as a Technician in your business as opposed to being FORCED to work as a Technician. More importantly, strategic networking will help you to focus on achieving and maintaining a business growth mindset. Be kind to others, smile and always keep the end in mind.

Yes, I learned and practiced many of the core capabilities and transferable skills that have helped make Blue Ink Homes successful. However, "It's not a case of being born into the 'right' family or going to the 'right' school – not anymore; today, the combination of social networking technologies and online publishing platforms means that anyone can develop and nurture a meaningful village of support based on trust and mutual respect with scale, in real-time, and virtually for free (personal effort notwithstanding)." Thank you Trevor Young.

Don't burn bridges! It is important to sustain positive relationships with everyone you encounter and I realize this can be challenging. I often joke about how my last six months at Dell reminded me of the character, Milton, from the movie Office Space (If you haven't seen this movie yet then you haven't lived!). I was still collecting a pay check but there wasn't much left for me to do since I had automated and systematized the majority of my workload. The time had come for me to take on more responsibility but I knew I wasn't going to deliver the results my team needed or the results that I was accustomed to delivering, so I decided to respectfully part ways and resign. However, as a result of maintaining a positive relationship with my former colleagues, some of them have approached me about investment opportunities while others have referred friends and family members

from THEIR inner circle to me. There is no way this would have happened had I disrespected them or treated them poorly.

Show Your Gratitude

Every "No" gets you closer to your next "Yes"! Always express your gratitude and be thankful and mindful of other people's time regardless of the end result. Always ask for constructive feedback incase there is an opportunity for you to implement change towards continuous growth and development. Embrace the change and implement it as you deem fit as you work towards becoming the best version of yourself personally and professionally.

This reminds me of the opportunity I had to sign an exclusive contract with a New York based production company. I was in the process of working with two production companies, one had presented me with a contract and the other, the one I preferred to work with, was not sure that they wanted to move forward with next steps. When they called me back and encouraged me to pursue the other contract, I immediately thanked them for their time and consideration but I also asked them to help me understand why they were no longer interested in working with me. I took every piece of constructive feedback that they gave me and implemented every change. However, I only implemented those changes because I believed in them and agreed with them. Don't implement change if you don't believe in it. I called them back months later, once I had successfully implemented all of their recommended changes, and I asked them to reconsider their position. By then, they had a whole new set of standards for me to implement and it was around that same time that I realized I no longer wanted to pursue that pillar of my business. However, I continue to follow up and have maintained each of the relationships that have developed.

20 Ways To Nurture Your Network

So, let's design an automatic sprinkler system for your network.

I've created a cheat sheet for you. It is an ideas bank of twenty ways you can nurture your network. Take five of those ideas and either implement them or work out how you can improve the way you currently do them, even more.

You can download my "20 Ways To Nurture Your Network - Cheat Sheet" at www.networkingwithamy.com

CHAPTER 6

It's Who You Know

Lesson #4: Networking unlocks opportunities money can't buy

There was a period when I was working two full time jobs and I needed to get organized so I immediately decided to hire a VA to help manage the day to day operation for my company. It took me a couple of weeks to narrow down my list of candidates to less than a handful, and I remember speaking to a young aspiring entrepreneur, Whitney, who blew me away. At the end of our Skype interview, I asked Whitney if she had any additional questions to which she responded with, "What are your short- and long-term goals?"

While I was pleasantly surprised with her level of maturity and ability to add value to the business, I was blindsided and impressed with the strategic questions she continued to ask. I went into detail about my vision and projected growth plans. I also informed Whitney that one of my long-term goals was to host my own home renovation show. Here is where the power of networking kicked in.

She immediately responded with, "Oh! Well, my mother used to work with one of the producers of House Hunters. Would you like an introduction?"

I thought to myself, that's cool! However, I wasn't a traditional home buyer and from what I understood, House Hunters did not work with developers. Fortunately, I was in the process of selling my primary residence, a condo located in a high-rise building in downtown Chicago, so I figured why not move forward with an introduction. If selected to be on the show, then it would be a cool process to experience while searching for my next home. More importantly, who knew what opportunities it could lead to! Less than one week later, I was introduced to Laura

How I Got On HGTV

Laura and I hit it off immediately. She was very personable and friendly but the interview process was long! Laura made it very clear to me that the network prides themselves on working with traditional

home buyers. I assured her that although I was an aspiring residential redeveloper, I was in the process of looking for a new place of my own so the timing was perfect. I did however want to buy a fixer upper with the intention of selling the home in three to five years which I was very transparent about. Fortunately, that wasn't a deal breaker since I was planning to move into the home. That said, I followed Laura's instructions and created my audition tape.

Originally, my aunt and I auditioned for the show. However, after our FIFTH audition tape, the network decided to inform us that it wasn't going to happen. They were interested in following a younger, more hip, "couple" throughout this journey. My family, aka my village, did such an amazing job raising all of us to have WAY more confidence than necessary at times so I wasn't hurt or offended by their comments. It was time to shift gears and begin my search for a new touring partner. I immediately thought about my good friend Mark. Mark had recently finished buying a place of his own so I casually approached him with the idea of appearing on this show with me.

Mark was immediately supportive and on board. I was very appreciative of his enthusiasm and willingness to help. Mark was going to have to take several days off from work and there was nothing in it for him other than helping out a friend. I had considered moving into several different neighborhoods close to Mark so he was already somewhat involved in the decision-making process so everything was starting to align well! I have known Mark for over ten years and he has always had my best interest at heart which the network immediately picked up on and loved! Mark and I submitted another SIX audition tapes and FINALLY the network agreed to move forward with the next step which was a Skype interview. My Realtor, Weston, had to send in an audition tape of his own as well. Fortunately, none of us were camera shy!

Overtime, I have learned that perseverance will prevail. Below is an email I received from Laura on May 31, 2014 titled, "Perseverance Pays Off!"

––––––––

Good Morning Amy,

I am sure that it is true for your business, and I believe the same is true for this situation :) We wouldn't be asking you to make another video if we didn't believe in you, and we really appreciate Mark being such a good sport. I already know he is going to be great on the show, and now we just have to put our best foot forward for the executives' approval... Also, I saw your posting yesterday looking for a photographer/videographer. I know that one guy was recommended at $250 a shoot. I have another suggestion for you as well, if you are willing to work with someone that is capable but doesn't have it on his resume yet. My favorite soundman in Chicago is a young guy named ████████ - He is freelance, and is working on transitioning to doing camerawork. He has already done shooting for other clients, and would give you a better rate! His email is ████████████ ████ and his cell is ████████████. He is actually working "as a local" with me this week on my shoot in Telluride CO, but he flies back to Chicago on Monday... Have a great weekend Amy!

––––––––

The reason I decided to share this email with you is to show you the value of following up, leveraging from the resources around you and the value of having a credible online presence. Be persistent! If I never would have followed up with Laura, she would not have been as open as she was to introducing me to her local network. This is the value of building rapport with others. This isn't something you do because you HAVE to, it's something you do because you WANT to.

Several weeks later Laura sent me an email letting me know that our show was approved! Mark and I were at brunch when we received the great news! This was a very foreign process for me, Mark and Weston but we had a great time learning about an industry that was new to us while building new relationships along the way.

Every episode took five days to shoot. The days were long but we cherished every moment. We spent time touring several different properties and I shared my renovation ideas with the crew once I identified the home I was planning to purchase. The team came back during mid construction to capture some additional footage of me and my General Contractor discussing the new footprint of the home. Little did I know that this was going to be the first of four episodes! http://www.blueinkhomes.com/check-me-out-on-house-hunters

The neighborhood I ended up buying in was a transitional neighborhood with high demand from young families. The project captured the interest of several neighbors and potential home buyers before the construction was completed. While I had no intentions of selling my home so quickly, I sat down with Weston and reconsidered my position. The buzz in the neighborhood combined with the fact that I had a major renovation going on sparked a new interest with Laura, who suggested that I audition for a follow up episode in hopes of appearing on House Hunters Where Are They Now. So that's exactly what I did!

The interview process was just as extensive and the network did not care that I had already appeared on one episode of House Hunters. Several weeks later, I received a follow up call from Laura letting me know that I had made the cut! We were excited to be working together again on a follow up show. This put me in a great position because the possibility of a career change was starting to align.

Although I felt blessed to be working at Dell, I was no longer passionate about what I was doing and I was really starting to enjoy my new-found passion of renovating homes. As I completed the renovation on my home for the show, I started to visualize a career change. I was torn between living in my house for a few years, per my original plan, or moving forward with listing my home with Weston. After much deliberation, I quickly realized that I had discovered a career that would allow me to leverage my strengths (networking, building teams and managing people) in a new industry that I loved!

My innovative side was starting to shine through and I was fascinated with the process of taking a dumpy old house and transforming it into something new and modern. I was prepared to make a massive career change by jumping into an industry I knew very little about. That said, the opportunity to showcase my first solo single family home renovation on national television was an opportunity I was not going to miss.

Episode two resulted in me filming another episode of House Hunters (episode 3) but this time as a buyer looking for an investment property which then resulted in me filming another episode of House Hunters Where Are They Now (episode 4). It was during this fourth episode that I finally announced I had made the career change and suddenly found myself managing five full gut renovations. You can check them out at www.amymahjoory.com

I was beyond grateful for the opportunity that Laura and the team at Pie Town Productions provided me with. I still hold some of those newly formed friendships close to my heart. I've introduced individuals and families from my local network to Laura for an opportunity for them to also appear on the show and since appearing on the show, several of my other homes have been featured on the network. My husband, Sean McNicholas, who is also a real estate professional appeared on episodes three and four with me as my touring partner and "friend". Since we are now married, the idea of filming a couple of follow up episodes has been discussed. None of this would have happened had I not implemented a follow up system, asked questions and used the power of networking to open doors.

Think "Who" before "How"

It is very common for people to lose sight of the end result. You will not always obtain the results you are trying to achieve by talking to one person or after meeting with someone one time. This is where the power of leveraging from the resources around you comes into play.

Most people associate networking with getting leads. However, what you choose to do with those leads is more important than simply gathering their information. This is where the speed of implementation

has a very powerful effect and the concept behind taking action now comes into play.

Successful people think about WHO needs to be on their team before they bother contemplating HOW to achieve their goals. While keeping the end in mind, you're going to conduct your due diligence and research your audience prior to meeting with them. Regardless of what your goals are, when you ask someone to take time away from their day to meet with you, you are selling them on the benefit to working with you by educating them on your systems, process and core values. It is important to think about who you are going to meet with before you think about the logistics behind how you are going to achieve your goals.

10 ways networking can help you

The power of networking encompasses many different dimensions - including but not limited to:

1. Source customers / projects
2. Find suppliers
3. Recruit staff / partners
4. Meet investors
5. Gain publicity
6. Benchmark your performance
7. Identify lessons learned/ implement best practices
8. Sense and anticipate changes in your market
9. Negotiate favorable terms / pricing
10. Invest into new opportunities

Whenever I coach and mentor others on the topic of strategic networking, I always encourage my students to remove the blinders and get creative! Don't think of networking solely in the traditional sense, as "the exchange of information or services among individuals, groups, or institutions; specifically: the cultivation of productive relationships

for employment or business." Its ok to think outside of the box, which includes networking with people outside of your industry!

Anyone you encounter can help you achieve your goals! Remember, referrals and word of mouth goes a very long way. It is important to make that strategic mind shift to where you've integrated networking into your day to day lifestyle. It's not something you're going to focus on once a month or even once a week. Networking is a strategy you will consciously focus on implementing daily and over time, the actions you take based upon your conscious competence, will result in networking becoming second nature and running on autopilot. Much like learning to ride a bike or drive a car, this is when you have truly mastered networking - it simply becomes an unconscious competence.

Implement a follow up system!

It is critical to stay in front of your audience for several reasons. First, this is a great way for you to continue to build rapport, loyalty and trust as you never know when someone may be able to lend a helping hand. This can be something as simple as a monthly follow up call. Second, leveraging from the use of a centralized database [iContact, Benchmark, Mailchimp, etc.] is a fantastic way for you to share your story and journey. Be transparent! Be free! Incorporating a monthly email blast to everyone in your database with a newsletter summarizing all your accomplishments and success will generate new and/or added interest. Even small gestures such as sending someone a thank you note or a personalized email also goes a long way. Gift certificates to coffee shops to thank them for their time, support and guidance are always appreciated. These are all great ways for you to stay in touch. It's also important to remember the small stuff such as birthdays, children, vacations, etc.

There will absolutely be naysayers out there, folks who will think that you're crazy, that you're wasting your time or that you're never

going to achieve your desired results. However, what's important is that you believe in what you are doing, you surround yourself with like-minded people, and you continue to use the power of networking to open doors. Disregard all negativity and shift your focus towards the end result.

The 20 Most Influential People Worksheet

Sit down - it's time to reflect.

Use this time to generate a list of the 20 most INFLUENTIAL individual people in your life.

It does not matter if these individuals have the same type of experience as you or if they can directly help you.

The reason you're going to focus on the INFLUENTIAL individuals is because they are people of influence! By sitting down with them and educating them on who you are and what you're doing, they will be able to point you in the right direction and ultimately connect you with other individuals who WILL have a direct impact on what it is you are trying to achieve.

Your job is to stay "top of mind" by following up with them periodically so that you're the first person who comes to mind when they come across a referral who may be able to help.

You can visit www.networkingwithamy.com and download a template for completing "The 20 Most Influential People In My Network" exercise I have prepared for you.

CHAPTER 7

YOUR VILLAGE SQUARE IS ACTUALLY A CIRCLE

Lesson #5: Networking is intentional

At the heart of most villages, you will find the village square. A village square is an open public space found in the heart of a traditional village used for community gatherings. Being centrally located, village squares are usually surrounded by small shops such as bakeries, markets, snack stores, and souvenir shops. At their center is often a fountain, well, monument, or statue. The concept of a village square transcends cultures - because people are social animals, that thrive from connection. People in village squares tend to congregate around their common interests and aspirations.

At the heart of your network, the virtual village you are building around you, you'll find YOU. Picture and imagine a series of concentric gated walls around you - and that you control who you place in each of those concentric rings. The walls represent your boundaries. The people permitted within your inner circle are your most trusted friends, family and advisors. The more time you spend with them, the more you allow their ideas and habits to influence yours, the closer they are to the center of your network.

Have you ever wondered why some people are so powerfully connected, are the first to hear about great opportunities, and earn more quality referrals?

The answer may surprise you. To attract more success in business, you don't have to network more; you just have to network more intentionally. This means becoming more focused, engaging, trusted, and memorable. And not necessarily with more people, but with "your people"—meaning the people who naturally bring the most value into your world and for whom you can bring the most value into their world.

> *"You are the average of the five people you spend the most time with."*
> *Jim Rohn*

This is a concept I didn't really start to understand or grasp until five years ago while building my real estate business.

Growing up, my mom would always make similar comments and worry, as a parent naturally should, about how hanging out with the wrong crowds may negatively influence my decision-making process. However, I remember thinking to myself, "I have my own belief system and can't be influenced into doing something I don't want to do." That's pretty much held true through my adult years. However, twenty years later and I FINALLY understand and see the value in what she was saying as hanging out with "the wrong crowd" never took my personal growth and development to the next level. Sure, I stayed out of trouble (for the most part) and although I was never easily influenced and I had a great time at school, my social surroundings never motivated me or inspired me to do more, to improve myself or to grow and challenge any aspect of my life. I always thought to myself, if people can't negatively influence me, then who cares who I hang out with.

Surround yourself with the right people

NOW I see how significant it can be to surround yourself with likeminded people and how it has propelled me to grow and develop in areas I never dreamed possible. No, this isn't me saying that I am

better than those who choose not to implement this concept. In no way am I saying that you MUST surround yourself with likeminded people in order to be successful. It's simply a concept that has worked for me. I am simply sharing my story and presenting you with a proven concept you may want to consider for yourself as you start to diversify your own circles - regardless of what your end result is.

It is your responsibility to surround yourself with the right people. It's not just knowing where to go to develop those relationships but it's just as important to know how to build and nurture those relationships. The idea is to grow your network through communication and trust - which all takes time to develop.

People aren't going to seek you out unless there is something specific they are looking for and something of value you can present them with. Even so, those individuals still may not fit into your immediate circle but that's ok! You're not going to write them off. We always want to give back and help others even when there is nothing in it for us, other than the pure satisfaction of helping out a neighboring friend.

Not everyone in your network is created equal

Diversity is a good thing! Certain folks will have a certain place in your your immediate and extended circles. Tap into them as needed (do this when they're not "needed" as well as you should actually ENJOY the people who are in your circle) but again, be selective and respectful and ensure you're also contributing something of value to the relationship.

Think of your network as a series of concentric circles. Each member of your circle should serve a purpose and play a specific role whether its personal or professional. However, this shouldn't be treated as a check the box type of an item or a "job". You should enjoy spending time with everyone in all of your circles. It should never feel

like a task or chore when spending time with your network. I have a huge cross functional network filled with friends (old and new), family, co-workers, mentors, etc. who I continue to spend time with. I value my time with each of them and each of them has helped mold me into the person I am today. More importantly, I enjoy spending time with them (in or outside of work) and I respect and value the time and energy they put into our relationship as well.

Networking in the right circles is how you're going to build your power team of A+ players. This isn't going to happen overnight but once you've got the right people on the bus, it's going to make your job a lot easier! Networking in the right circles WILL have a positive impact. The cool thing about applying this concept is that the bar never stops rising, but in a good way!

You also need to understand and appreciate that people will move inward and outward in your concentric circle model over time. Sometimes, they'll even move out of your circles all together.

Your closest friends - your inner circle - at high school, may or may not still be in your life. One or two of them may still be in your inner circle while others may be in the second, third, fourth, fifth, sixth or seventh concentric ring - acquaintances now, that you see once or twice a year rather than once or twice a day. I lost one of my best friends several years ago and fought hard to keep the friendship intact. It was a respectful and mutual decision to part ways but it was hard for me to accept because we had been such good friends for over thirteen years. However, overtime I have come to the realization that people come into your life for a reason and its ok if those relationships have an expiration date. Some relationships are seasonal and will expire over time but look at the silver lining and always remember the purpose and value that relationship served.

In the book "The Circles", Kerry Armstrong gives you the opportunity to examine - without judgment - how you feel about the people in your life and where they fall within your seven circles,

or seven tribes. Pick up a copy if you're interested in learning more.

Networking in the right circles

When it comes to networking, you can take this concept of a concentric set of circles and apply it to different formal networks you choose to join and participate in. For example, you may choose to join a formal networking group like Business Network International (BNI). Local chapters of BNI groups meet regularly to support each other by actively looking for leads and introductions for fellow group members. You'll find that there are leadership roles available to members - like chairing the regular meetings, presenting a weekly educational section, recruiting and inducting new members, etc. Taking on one of these leadership roles would move you towards the center of that group.

The MindMap Your Networks Exercise

When it comes to taking a more strategic approach to networking, it is helpful to create a mind map showing your past, present and future networks. What networks are you currently active in plus which ones would you consider joining and participating in, in the future?

Some of these networks will have a minimum duration you need to commit for. BNI for example requires you to sign up for a membership. You might find that after spending a year active in one chapter, you sense that it is time to move on to another chapter or alternative networking opportunity. You can then review your networking mind map as a kind of "ideas bank" of where to next. Having a mind map like this is also a great place to add new ideas and suggestions from people within your network on the most vibrant "villages" they are enjoying being active members of.

To help you get started on mapping your network, I've created a cheat sheet for you. It is an example of a networking mind map you

can use to help stimulate your thinking as you sit down to do this exercise. I want you to take five of those ideas and either implement them or work out how you can improve the way you currently do them, even more.

You can download and example of a "Networking Mind Map - Cheat Sheet" at www.networkingwithamy.com

CHAPTER 8

VILLAGENEERING

Making it happen

At the end of the day, we master only that which we put into practice.

Being a residential redeveloper isn't backbreaking work, but it is a lot of work.

During the first six months of my new career path, I didn't tell anyone what I was doing. There were mixed reactions to my new career path. I've lost friends throughout this process and many family members were not supportive. I recognized their negativity, but it was disregarded. More importantly, I never let it impact my state of belief. I knew I was capable, whether everyone else supported me or not.

When you're faced with negative feedback, try to recognize when to receive it as helpful advice and when to let it roll off your shoulders. Not all criticism is given with good intentions, but sometimes it is given in love - even if it doesn't feel like it at the time. Always view constructive criticism as free advice.

The concept of surrounding yourself with likeminded people was a very important concept for me to implement and its had a snowball effect on my personal and professional life. Especially over the last two years. Regardless of what you aim to achieve in life, there will be people who don't support you. Surrounding yourself with likeminded

people is essential to your success. It's not about thinking you're better than anyone else; it's about creating a support system. When you're surrounded by people with common goals and objectives, you will be motivated and inspired by them.

What I've also learned during these past five years is how important it is to keep business relationships alive. Following up with people is key! This was a tough concept for me to grasp at first, but I quickly realized that I had missed out on a ton of opportunities because I failed to implement a system that would allow me to follow up with others in a timely manner.

Don't let those who aren't supportive of you keep you from following your dreams. If you're thinking of making a big change in your life, then it's important that your mindset shift encompasses the drive and discipline required to remain focused on the end result.

Follow up with the people who will help you grow your business.

Recognize the negative people and stay focused on the good.

Remember - it takes a village to raise a child but it takes a network to raise an adult, to become (and contribute) everything they can be.

Engineer your network as a "virtual village" by using the five lessons we've covered together in this book:

- Lesson #1: Networking is a daily habit
- Lesson #2: Networking is personalized marketing
- Lesson #3: Networking begins with giving
- Lesson #4: Networking unlocks opportunities money can't buy
- Lesson #5: Networking is intentional

Use the techniques and tools that I have shared with you to help accelerate the rate at which you grow and cultivate your network.

Believe in yourself and you will do great things.

I may have lost some friends and family support through the process of being determined to inspire others and live my purpose with passion.

However, I have also won the encouragement of new friends and earned a new level of respect within my family, including my dad who eventually came around to appreciating and respecting the unfamiliar path I have chosen to walk. I'll never forget that evening on March 14, 2014 when I was seated in the kitchen of my aunt's house in Chicago and my dad called. I immediately assumed something was wrong since it's rare for my dad call. We speak daily but it's usually my mom who calls and then passes the phone to my dad. It's always been my dad who

would call when something tragic has happened. So naturally, when I saw "Dad Cell" on my phone, I got nervous. However, little did I know that he was FINALLY calling to acknowledge my new career and to congratulate me for everything I had worked so hard to accomplish. The first words out of his mouth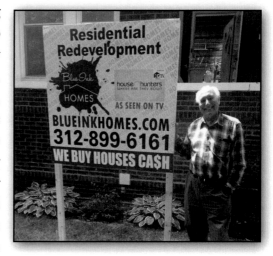

were, "I'm calling to tell you how proud I am. I didn't think you could do it." This was the first time my dad had EVER even acknowledged any of my work outside of Dell. He never even brought up the topic of real estate or asked me how things were coming along even after I had successfully renovated multiple homes and was under contract with HGTV. Fortunately, now he can't stop talking to others about what I do, how I was featured on a national television network and how proud he is of everything I've accomplished. It doesn't matter how old you are. You'll still seek your parent's approval and support when conquering milestones throughout your life. This photo was taken the very next weekend when my parents drove to Chicago and my dad asked to walk through a few of my properties.

Some of the people around you may be conflicted when you venture out into unchartered territory. That is ok. Often, their love and concern for your welfare shows up as doubt, skepticism, cynicism and resignation. People come in and out of our lives, leaving us forever enriched. Your network is not static but will continue to grow and evolve as you and the world around you continues to evolve.

"Twenty years from now you will be more disappointed by the things that you didn't do than by the ones you did do. So throw off the bowlines. Sail away from the safe harbor. Catch the trade winds in your sails. Explore. Dream. Discover."

- Mark Twain

Made in the USA
Coppell, TX
13 April 2023